The Passion of Images

Riemschneider Lectures

Staatliche Akademie der Bildenden Künste Karlsruhe

Verlag der Buchhandlung Walther und Franz König

Getting to the bottom of images, to their ground, has been a pursuit of Gottfried Boehm's for many years. In *The Passion of Images*, however, his reflections on the foundations of the iconic lead less to its supposed core and more to the crises and margins of images, where they threaten to dissolve, where they face their own collapse, and where we run the risk of losing sight of them.

One of the subtle surprises of this small, dense work is how Gottfried Boehm identifies, precisely in the margins of images, the basis of their entire potential: the undetermined ground from which they rise and into which they withdraw. *The passion of images* is revealed in the varieties of an iconoclasm that is immanent to the image, whether it is in the hide-and-seek of camouflage or trompe-l'œil or in the variations of dedifferentiation performed by cave paintings, Rorschach klecksographs, or minimalist painting. We thank the author of the second Riemschneider Lecture at the Kunstakademie Karlsruhe for his contribution as well as the Riemschneider Stiftung for its generous financial support.

Harald Klingelhöller
Carolin Meister

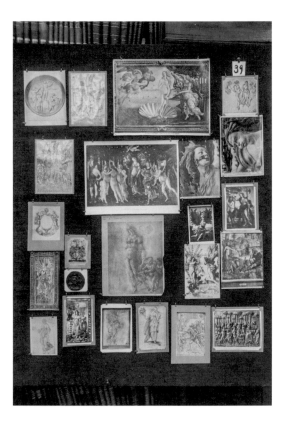

Fig. 1 **Aby M. Warburg**, MNEMOSYNE BILDERATLAS,
panel 39, final version, autumn 1929
Original photograph by the KBW Hamburg
(photographic collection, Warburg Institute London)

Gottfried Boehm

The Passion of Images

Images are the source of manifold effects. Even someone who primarily uses images for the purpose of information, knowledge, or illustration would probably concede as much. When I speak in what follows of the passion of images, I am referring to the sum of everything that makes pictures come alive: all the affects and antagonisms, the forces and contrasts, that engage us when we look at them. Images have been called "unmoved movers"; paradoxically, their physical stillness is able to elicit a rich temporal register. The keyword *passion* can therefore also be used as a key, because it connects active and passive moments, the sensations of perceiving subjects and the intensity of something made.

Whoever engages in such investigations is encouraged by Aby Warburg's eccentric and subtle mind (fig. 1); he was probably the first to sense that images have their own "pathos formulas." This brought their psychic energy into the bright light of fresh concepts without thereby weakening it.

A singular conflict

Images are things and share the material fate of those things. Yet they are at the same time endowed with not-thing-like, immaterial qualities. These are commonly captured with words like *expression*, *style*, *meaning*, *liveliness*, *effect*, and *force*. This astonishing interpenetration of completely opposed realities is what we call an *image*; it is what we look at and use as an image in a thousand different ways. At the basis of the image is thus a structural conflict that one may refer to as *singular* because it is tied to a particular imprint and so can only occur once in this particular way. No image, not even the most faithful copy, is like another; they are fundamentally different. This is manifested in each case as an elementary difference between the field of representation and what is represented, a difference that our experiences draw as do all discussions attempting to decipher the enigma of pictorial representation. Modern art was particularly interested in this conflictual side of the iconic and elaborated it: one thinks of, for example, Jean Dubuffet's and Frank Auerbach's works, in which pictorial physiognomies wrest themselves from the chaos of deep material submersion (figs. 2 and 3).

The liveliness and potency of images have long been registered as noteworthy but also as dangerous. This is evidenced by a forking path in cultural history

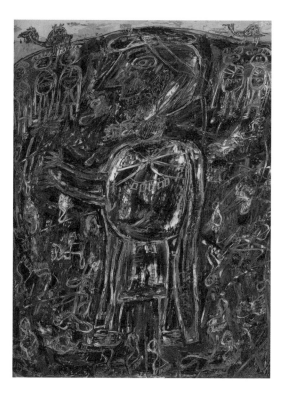

Fig. 2 **Jean Dubuffet**, Arab with Footprints, 1948
Oil on canvas, 92 × 73 cm
Staatliche Kunsthalle Karlsruhe

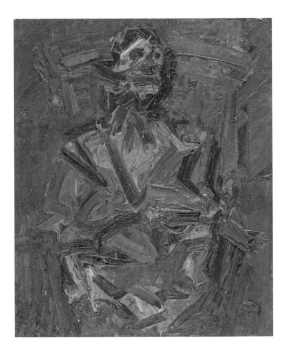

Fig. 3 ***Frank Auerbach***, J. Y. M. Seated No. 1, 1981
Oil on board, 71.1 × 61 cm
Tate Gallery, London

that passes through the non-European world as well; expresses itself in myths, legends of painters, stories of wonders, and also historical reports; and even preoccupies art treatises and aesthetic and academic literature.[1] The much-discussed power of images is very often ascribed to the artist's creative imagination, which is exemplarily embodied in figures like Pygmalion and the artist as a magician or as a divine or original genius.[2]

Through the middle of this tense terrain runs a singular line of conflict, the likes of which we do not otherwise encounter in cultural history. Entrenched on its two sides are the manifest forms of image worship (iconolatry) and image rejection (iconoclasm), which encompasses various types of negation including physical destruction.[3] If one is looking for strong evidence of why the passion of images is

1 With his attention to energy in works from the Renaissance, Aby Warburg was a key figure in this expansion of experience. See Aby Warburg, *The Renewal of Pagan Antiquity: Contributions to the Cultural History of the European Renaissance*, trans. David Britt (Los Angeles: Getty Research Institute for the History of Art and the Humanities, 1999); David Freedberg, *The Power of Images: Studies in the History and Theory of Response* (Chicago: University of Chicago Press, 1989); Louis Marin, *Des pouvoirs de l'image: Gloses* (Paris: Seuil, 1993); Philipp Stoellger and Martina Kumlehn, eds., *Bildmacht, Machtbild: Zur Deutungsmacht des Bildes; Wie Bilder glauben machen* (Würzburg: Königshausen & Neumann, 2018).

2 See Ernst Kris and Otto Kurz, *Legend, Myth, and Magic in the Image of the Artist: A Historical Experiment* (New Haven: Yale University Press, 1979); Victor I. Stoichita, *The Pygmalion Effect: From Ovid to Hitchcock*, trans. Alison Anderson (Chicago: University of Chicago Press, 2008).

such an extraordinary anthropological phenomenon, one can discover it in this long history of rupture, which has characterized the existence of images up to today. The iconic conflict thus plays a constitutive role in the history of the image.

The battle lines where this conflict ignites in theology, power politics, and art prove to be flexible and not at all distinctly defined. Yet one should keep in mind the unyielding dogmatic norm named at the very beginning of the Ten Commandments in the Old Testament: "You shall not make for yourself an idol. … You shall not bow down to them or worship them."[4] The commandment says that there cannot and may not be any graven image of Yahweh, the unfathomably almighty God, first of all simply because every image has to materialize and so circumscribe him. In other words, probably the oldest transmitted document of image theory contests the right of images to exist and demands their destruction. Iconoclastic tendencies are inevitably concomitant with monotheism, at least in its dogmatically pure form, and they have in fact appeared throughout history as groundswells in numerous religious and political

3 See Gottfried Boehm, "Ikonoklasmus: Auslöschung – Aufhebung – Negation," in *Wie Bilder Sinn erzeugen: Die Macht des Zeigens* (Berlin: Berlin University Press, 2007), 54–71.

4 *The New Oxford Annotated Bible: New Revised Standard Version with the Apocrypha; An Ecumenical Study Bible*, ed. Michael D. Coogan et al., fully rev. 4th ed. (Oxford: Oxford University Press, 2010), Deut. 5.8–9.

iconoclasms from Byzantium through the Reformation up to the present. They reflect, like a caricature, the respect and fear for the power of images.

The occidental history of images would not have developed so fully if a reconciliation of this conflict had not been possible. Indispensable for this was the story of Christ's life presented in the New Testament. As the veritable son of the invisible Almighty, he provided the greatest legitimation to the idea of pictorial representation. In the Epistle to the Colossians, Paul calls Christ "the image of the invisible God, the firstborn of all creation."[5] If Christ is already an image, then the right of images to exist is not fundamentally in question. This insight has prevailed in numerous disputes about images since Byzantium; it has been one of the foundations of occidental image culture.[6] Images acquire their right to exist by disclosing sacred contents. It is not their material being as images that is to be worshipped but rather the subject matter of the representation. This leads, however, to the development of a secondary attention to the modalities of representation, which one calls image consciousness.

5 Col. 1.15.
6 See Marie-José Mondzain, *Image, Icon, Economy: The Byzantine Origins of the Contemporary Imaginary*, trans. Rico Franses (Stanford: Stanford University Press, 2005); Marie-José Mondzain, *L'image peut-elle tuer?* (Paris: Bayard, 2002).

This process can be exemplarily demonstrated with the history of the icon.[7] Its prototype was the Mandylion (fig. 4), a (damp) cloth in which, according to legend, Christ's features were permanently imprinted. This was made plausible by concurring stories, the Abgar legend and the legend of Veronica. They ensure the truth of the pictorial referent, which became embodied in the image autopoetically, that is, without the shaping interference of an author. After that, icon painting strived for centuries to secure the authenticity of this prototype. The image acquires its power through the visual presence of Christ, the Madonna, or saints, but it can only do so by cultivating iconic valences. But in the end, the prototype of the Mandylion—that is, the copy of a face—leads to the question of the status of the image. It should be capable of embodying the invisible.

Embodiment thus proves to be the general intention of visual art, even after religious and mythological iconographies have faded. What I call the singular conflict appears in a whole new way in incipient modern art starting in the nineteenth century. Modern art itself has therefore been described as a dispute about images, since it fundamentally calls into question the central preconditions of representation.[8] One can perceive this in the excessive search for the

7 See Hans Belting, *Likeness and Presence: A History of the Image before the Era of Art*, trans. Edmund Jephcott (Chicago: University of Chicago Press, 1994).

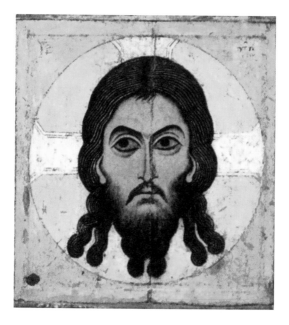

Abb. 4 **Mandylion Christi**, from Nowgorod, 1130–1200
Tempera on wood
State Tretyakov Gallery, Moscow

"first" or "last" image, an "original" pictorial work characterized by its remoteness from form, a work that reveals realities free of objects. This search began in Malevich's icons of "pure sensation" and continued with Duchamp's breaking of pictorial conventions and then on with Barnett Newmann (fig. 5), Marc Rothko, Ad Reinhardt, and many others.

What ties these forays together is the attempt to bring into play the "nonpictorial" in the image—for example, the sheer materiality of the canvas and paints or the gestural modalities of deformation—the attempt to show to what degree images are based on absence and negation and how they reveal something as a visual event. This great history of probing the power of images can take a sentence from Theodor W. Adorno's *Aesthetic Theory* as something like its motto: "Aesthetic images stand under the prohibition on graven images."[9]

I call the iconic conflict singular in part because it only takes place in the pictorial medium and is unknown in dance, music, and the linguistic arts. It

8 See Johannes Gachnang and Siegfried Gohr, eds., *Bilderstreit: Widerspruch, Einheit und Fragment in der Kunst seit 1960* (Cologne: DuMont, 1989); Bruno Latour and Peter Weibel, eds., *Iconoclash: Beyond the Image Wars in Science, Religion, and Art* (Karlsruhe: ZKM | Center for Art and Media; Cambridge: MIT Press, 2002).

9 Theodor W. Adorno, *Aesthetic Theory*, ed. Gretel Adorno and Rolf Tiedemann, trans. Robert Hullot-Kentor (London: Bloomsbury Academic, 2012), 144.

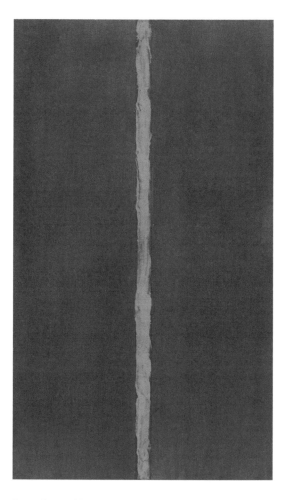

Fig. 5 **Barnett Newman**, Onement I, 1948
Oil and masking tape on canvas, 69 × 41 cm
Museum of Modern Art, New York

apparently requires a material embodiment, a corporeal "incarnation," so as to be open to attack by iconoclastic energies. Only physical bodies can fall and pass away—or also survive the test of time. The passion of images is not externally attached to them. It is also not projected onto them from the outside, even though it remains true that pictorial works could not unfold their potentialities without the eye of the beholder. This passion is a differentiating event and tied to the process of embodiment. It belongs to the iconic DNA.

Participation and evocation

Pictorial embodiment is tied to affection. The image's existence as an object *for itself* is manifested in its existing socially *for us*. One can thus read an innate countenance in all images and not just in portraits. They address themselves to a usually unknown but socialized audience and have done so in places specifically institutionalized for such encounters, including rites, graves, churches, and palaces, and then later in private spaces for connoisseurs and art lovers, which finally further developed into the white cubes of galleries and the mass exhibitions of museums. This affection, acted out through the use of images, is answered by the attention of viewers, who devote their emotions and memories, knowledge and education, to images. The associated discourse of "the" viewer is fraught with abstractions, but they can be resolved since images are tied to recurring and communicable experiences—which does not exclude empty consumption. First, reciprocal participation (in Greek, *methexis*), in which the beholder's perception builds on the material image, completes the image's integral intention, which Ernst Cassirer called symbolic form. The word *symbol* here regains its concreteness when one recalls its original meaning. The Greeks referred to the friendship ring that was broken at a farewell as a symbol because fitting together (in Greek, *symballein*) its scattered parts ensured that even after a long time apart, one would

recognize a friend. From this then developed the figure of legal identity such as in the form of passports.

In the image, the fitting together of scattered halves takes place when the beholder's gaze actualizes the latency of the representation. The realized sight (one side of the symbol) fits snuggly into the presented view (the other side); or to elevate it to a general level following Wolfram Hogrebe: "What grants fit [Passung] to the knowable also grants it to knowing."[10] Here *fit* refers to the precondition for the success of methexis in viewing, what allows methexis to exceed the radius of what is known and the beholder to experience new worlds. Images are capable of doing this because their stasis proves to be a dense potential that even continued actualizations cannot exhaust. Everything that they show is tied to a halo of indeterminacy that invites us to see the same thing differently. For this, Georg Misch introduced the concept of the evocation of meaning, which expands on the activities of interpretation and understanding by elaborating thoughts Wilhelm Dilthey condensed in the pregnant sentence: "Only what affects us is there to us."[11] For me, *evocation* is a welcome

10 Wolfram Hogrebe, *Duplex: Strukturen der Intelligibilität* (Frankfurt am Main: Vittorio Klostermann, 2018), 104.

11 Georg Misch, *Der Aufbau der Logik auf dem Boden der Philosophie des Lebens: Göttinger Vorlesungen über Logik und Einleitung in die Theorie des Wissens* (Freiburg im Breisgau: Karl Alber, 1994), 524–33; see also Wolfram Hogrebe, *Szenische Metaphysik* (Frankfurt am Main: Vittorio Klostermann, 2019). The Dilthey quote is from

word because it does justice to the fact that images not only define something but also make it possible to see in multifaceted ways. This is also denoted by the word *phenomenon*, whose meaning Husserl and Heidegger rediscovered by emphasizing the activity, the verbal side (in Greek, *phainesthai*), contained in the concept.[12] Knowing is then not related to the usual *Gegen-stand* (object) or *Gegen-wurf* (Albrecht Dürer) but rather to something that shows itself in the object, reveals itself. This pictorial power of illumination is disclosed in a situational embeddedness, in an answering perception. It replaces the common statically conceived subject–object model, which localizes things or places them "across from" us as if on a stage. By contrast, *evocation* describes a surplus of meaning that allows images to show something and to show it always differently.

In this context, some also speak of "responsive meaning" (entgegenkommender Sinn), which does not primarily want to be named and determined but rather corporeally performed.[13] This draws atten-

Wilhelm Dilthey, "Psychologie als Erfahrungswissenschaft (ca. 1888/89)," in *Gesammelte Schriften*, vol. 21, P*sychologie als Erfahrungswissenschaft, Teil 1: Vorlesungen zur Psychologie und Anthropologie (ca. 1875–1894)*, ed. Guy van Kerckhoven and Hans-Ulrich Lessing (Göttingen: Vandenhoeck & Ruprecht, 1997), 325.

12 See Martin Heidegger, *Being and Time*, trans. John Macquarrie and Edward Robinson (London: Blackwell, 1962), 51–55.

13 See Franz Engel and Sabine Marienberg, eds., *Das entgegenkommende Denken: Verstehen zwischen Form und Empfindung* (Berlin: Walter de Gruyter, 2016).

tion to its form, to the sensual how of representation and embodiment, as well as to the associated energies and forces. In such an actualizing performance, beholders function as resonating bodies, responding and activating their productive aptitudes in the act of reception. I mention this also because I would like to counter the widespread understanding that meaning is exclusively projected onto images by constructive acts of the brain. With *responsive meaning*, the possibility remains in play that beholders participate before they describe or comment. Bearing witness to the image precedes statements about it. The beholder does not point to something, but rather the image reveals something: the logic of the image itself, which is to be deciphered in detail. It is not coincidental that images are characterized as agents, acts, events, phenomena, or even epiphanies—precisely because at the core of their material heaviness, they are temporally composed and able to accomplish the genesis of their meaning.

To play on a metaphor of the philosopher Johann Gottlieb Fichte, one could say that an eye appears to be inserted in the image. This eye is both naturally (physiologically) and historically determined. One can thus not only speak of a "history of seeing"; one can also even risk the grand thesis that the history of occidental consciousness has been generally determined oculocentrically, that knowledge has always been acquired through the mode of seeing.[14] I'll leave

this claim to the side, since it is, in the end, a matter for the philosophy of history and extends far beyond the reality of images. Yet it also sheds light on the question of images and on how we deal with seeing every day. Seeing strives for certainty; it wants to see confirmed what it knows. From this perspective, we continually practice anamneses that contribute to an objectifying recognition of things.

But this reduces the spectrum of human perception, which encompasses numerous other sensory capacities. It is not coincidental that one speaks in this context of feeling, a complex ability that is capable of recognizing dynamic aspects of reality and so comes closer to what is revealed in images. One does not have to be a physicist but rather just to go for a walk to register that the world is not only made of stable objects but also of energies, atmospheres, rhythms, and vibrations, all of which we intuitively feel out with our capacity to resonate with them. Something similar recurs in images, for example, in a color arrangement that transmits forces. Even a first fleck in the image field proves to be defined not only metrically (for example, through its distance to the edges) but also as an ambiguously effective entity that addresses itself. In this initial beginning scene, the image is already there because a simple marking like a fleck of color is enough to articulate the ground.

14 See David Michael Levin, ed., *Modernity and the Hegemony of Vision* (Berkeley: University of California Press, 1993).

The point of indeterminacy

Ascribing the passion of images to attractive (or also repulsive or overwhelming) themes corresponds to a widespread understanding. All the possible varieties of "thrills" are especially widespread and successful in film. Whoever ascribes their power only to the narratives represented will have a hard time explaining why even totally stripped representations can be lastingly and powerfully effective. That is why I am pursuing the thesis that the origins of pictorial power are already present in its first elementary markings. Artists have probably always known this, and they have also reflected on it at least since early modernism. Thus, before more-detailed experiments on iconic elements were conducted in suprematism and the Bauhaus,[15] a klecksographic aesthetic established itself as a bizarre side branch in modern art, calling attention to the power of the formless and coincidental (fig. 6).[16] To this line belongs Ed Ruscha's engagement with blots, manifested in his portfolio *Stains* (fig. 7), which gathers together seventy-five different kinds of stain formations and just as many modes of effect. There are stains that emerged from the

15 See Kazimir Malevich, *The World as Objectlessness* (Ostfildern: Hatje Cantz, 2014).

16 See Raphael Rosenberg, *Turner, Hugo, Moreau: Entdeckung der Abstraktion* (Frankfurt: Schirn Kunsthalle; Munich: Hirmer, 2007), 86–97.

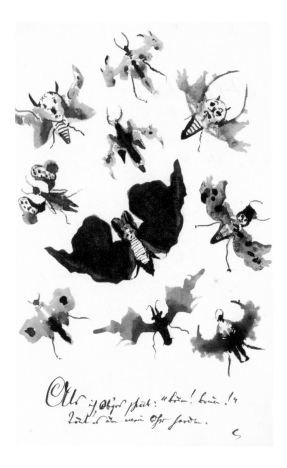

Fig. 6 **Justinus Kerner**, Klecksography
Deutsches Literaturarchiv, Marbach

Fig. 7 **Edward Ruscha**, Ketchup (Heinz) from "Stains", 1969
Mixed media, 30 × 27 cm
Museum of Modern Art, New York

salt water of the Pacific, from candle wax, ketchup, egg whites, and oil paints, and even from the special sap of a drop of the artist's blood. Whoever leafs through this portfolio sees that under pictorial conditions, coincidental visual events already transmit energies. The "power of the weak" is, in any case, more than a mere figure of speech; guided by the relevant remarks of painters, writers, and theorists, we can follow this power to the core of the question of images. One of the proper names of this small power was the power of the "vague," the "vaghezza," which means a power of nuance or indeterminacy.[17] With the great history of rational progress in European modernity, which drove the scientific and technological mastery of nature, an attention emerged for phenomena bordering on indistinguishability. Out of this attention, Leonardo da Vinci was probably the first to develop a painting strategy (fig. 8). It became known to everyone under the designation *sfumato*, an Italian word in which the allusion to smoke (*fumare*) or fog plays a role. In any case, the point is that there is no defect in the visual blurriness associated with this

17 See Remo Bodei, "Vage/Unbestimmt," in *Ästhetische Grundbegriffe: Historisches Wörterbuch in sieben Bänden*, ed. Karlheinz Barck et al., vol. 6 (Stuttgart: J. B. Metzler, 2005), 312–30. Bodei describes a double origin of the concept and its bifurcation from antiquity into the nineteenth century. Etymologically, it comes from the Latin *vacuus*, meaning "vacuous" or "empty," and *vagus*, meaning "wandering." See also Gerhard Gamm, *Flucht aus der Kategorie: Die Positivierung des Unbestimmten als Ausgang aus der Moderne* (Frankfurt am Main: Suhrkamp, 1994).

technique but rather an intensified vividness. In atmospheric sfumato, the conceptual differentiability of single things fades in favor of a fluid phenomenal value. This changes the conditions of perceiving the image altogether: proximity and distance oscillate; the gaze glides over the surface without fixating on details; the atmospheric dominates.

Leonardo da Vinci's historical service consists in having transformed these familiar experiences of animated indeterminacy into an ordered technique of painting. The embodiment of positive indeterminacy in charm, attractiveness, or a smile did not have to be invented; it had long been present, for example, under the concept of grace; what was new was how he entwind it with the logic of the image.

I want to emphasize three aspects of this complex historical process. The first maintains that the detailed nuances first practiced by Leonardo were highly calculated and served as a basis for Venetian colorism, especially Titian's late work, to build on further (fig. 9). Within landscape painting, Jan van Goyen and Claude Lorrain then developed an atmospheric type (fig. 10), a type that stresses the energetic economy of nature. Jean-Baptiste-Siméon Chardin later began to base his whole technique of painting on the arrangement of "atoms" of color, before in the nineteenth century, first Turner (fig. 11)—and then, more strongly, impressionists

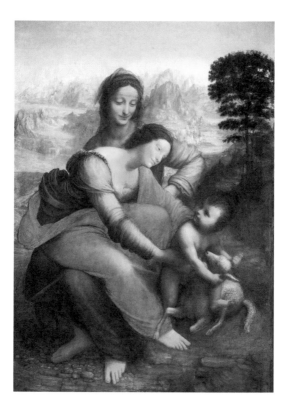

Fig. 8 ***Leonardo da Vinci***,
The Virgin and Child with Saint Anne, ca. 1503–1519
Oil on poplar wood, 168 × 130 cm
Louvre, Paris

like Monet and Seurat—understood the world as appearance. This series of examples continues into the twentieth century with artists like Morandi and Rothko—or European abstractionist painters like Graubner, Verheyen, Girke, Jochims, Geccelli, Erben, Gross, and others—who unfolded the productivity of the indeterminate with great intensity.

The second aspect concerns the consequences of perceiving the indeterminate. What cannot be differentiated also cannot be captured using declarative sentences. The advancement of nuance provokes a language crisis.[18] It is becoming clearer and clearer that even when images negotiate linguistic references, they are dominated by a languageless showing inherent to the image. Contents that come under the visual conditions of sfumato are conveyed more and more on a preverbal level in mysterious silence.

Breaking open the difference between how the image deictically places something before the eyes and the presentation of linguistically comprehensible reference points was an important process in the history of the image. It poses the question of the intersection of showing and saying in a whole new way.

18 See Christiaan Lucas Hart Nibbrig, "Was ist eine Nuance?," *Merkur*, March 2015, 83–91.

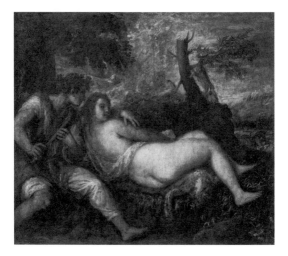

Fig. 9 **Tiziano Vecellio (called Titian)**,
Nymph and Shepard, 1570–1575
Oil on canvas, 150 × 187 cm
Kunsthistorisches Museum, Vienna

Here I will only briefly note the third aspect. It can be expressed in a concise question: What specific insight does the nuance or presence of the indeterminate provide with regard to the logic of the effects of images? Or: What does pictorial passion have to do with the indeterminate, particularly seeing that beholders of images are usually interested in their informational content? What museum visitors don't already know is told to them by the title of the image, exhibit labels, catalogue essays, and finally by the audio guide, which leads them through the rooms. It is the bud in the ear that directs their seeing: it feeds them with iconographic, biographical, stylistic, and historical information, allowing them to reconcile their perception and knowledge. According to this logic, the image appears as a position within the cultural network of information. Beholders see—and only see—what they know, and they know what they have seen. If one understands images as effective entities or sources of power that, among other things, arouse affects and create other presences, then we cannot go any farther along this path.

It is therefore not surprising that within art history, especially Aby Warburg undertook attempts, for example, to decipher the pathos of images using "pathos formulas."[19] In an entirely different way, Max Imdahl supplemented cognitive seeing with a "seeing seeing" (sehendes Sehen) that directs its

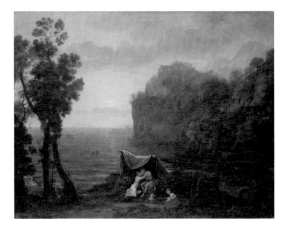

Fig. 10 **_Claude Lorrain_**, Landscape with Acis and Galatea, 1657
Oil on canvas, 102 × 136 cm
Staatliche Kunstsammlungen Dresden

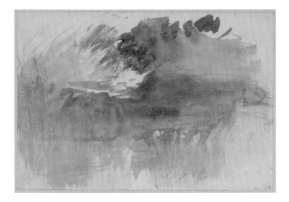

Fig. 11 **_William Turner_**, A Storm over the Rigi, ca. 1844
Watercolor on paper, 25 × 37 cm
Tate Gallery, London

attention to the dynamic, nonconceptual aspects of the iconic,[20] not in order to polemicize against the role of historical knowledge but rather to clarify its limits and to offer it help in retracing the experience of effects. The accusation of "mere subjectivity"- was quickly raised and used as a methodological-guillotine to criticize these attempts. The counterargument is that this phenomenon has to do with genuinely pictorial qualities that doubtlessly require a knowing subject.

19 The conceptual spectrum of pathos has been discussed in Kathrin Busch and Iris Därmann, eds., *"Pathos": Konturen eines kulturwissenschaftlichen Grundbegriffs* (Bielefeld: Transcript, 2007). To this spectrum also belong terms like infection, encounter (*Widerfahrnis*), immersion, etc., including the "arousing images" (*Erregungsbilder*) Aby Warburg elaborated; see Horst Bredekamp, *Image Acts: A Systematic Approach to Visual Agency* (Berlin: Walter de Gruyter, 2018).
20 Max Imdahl, "Cézanne – Braque – Picasso: Zum Verhältnis zwischen Bildautonomie und Gegenstandssehen," in *Gesammelte Schriften*, vol. 3, *Reflexion – Theorie – Methode*, ed. Gottfried Boehm (Frankfurt am Main: Suhrkamp, 1996), 304–5.

Divided attention

We respond to images that structurally present themselves as differences not simply through seeing but rather through what I call divided attention. Through socialization, we learn to differentiate between the scene of the iconic process and the details presented there (in the form of figures or figurations). Much depends on recognizing the difference between the representation and the represented, in particular the qualitative contradictions and visual conflicts it contains, at least if one wants to understand images as systems analogous to language. That is certainly not self-understood, because we actually tend to identify pictures with what is "on" them. Images are equated with their content, representations with what they represent. This procedure is surely legitimate and is also the basis of the established nomenclature that draws on the represented persons, things, natural scenes, and narratives as the criteria for saying what each image is. It would be naive to want to change this ingrained practice, yet one should see what it always conceals: namely, the ways of seeing that are formed in images and become manifest in the views they present. For this, we can take from photography the concept of focus, which refers in camera and film technology to a particular control and shaping of attention. How a person taking a photograph sees her subject and how she thinks about capturing this view employs technical parameters like the aperture,

focal length, and depth of field of the eyepiece; and she uses her body to bring the apparatus into position so that canted angles, microscopic proximity, and panoramic distance can emerge. It is also not surprising that this representational interaction of the subject with her world also offers resonant starting points for philosophy, not least for phenomenology: Husserl integrated the concept of focus into his conceptual world, allowing us to better understand the accomplishment of divided attention.

A particular focus not only captures an object but also its horizonal manifestation. Things are not presented individually and in isolation but rather always in a visual context or continuum. They are not simply there but are rather shown in their location. This is indeed precisely what the central concept of the phenomenon means. Here, the concept of divided attention argues that in the individual thing, we always also see, as gazing beings, the context, that we are able to pay attention to the obvious difference. But the horizonal givenness of things also indicates that dividing attention takes place situationally and flexibly. The concept of focus seems at first to be conceived statically.

The horizon is always also the flexible threshold between the manifest and the invisible. In the image, the horizon then experiences a double transformation. The first aspect consists in bringing to rest, and the second in an animated materiality. The image

not only shows, if applicable, something thinglike; it is itself a thing, though one in which the iconic difference between surface and distinction has durably formed, with the consequence that the two moments can be seen as a tense contrast, at whose basis is the fundamental conflict I talked about at the beginning of this essay. It is a fundamental conflict because it articulates the transition from materiality to meaning and thereby the beginning of all human and cultural work. Visual difference consists, in any case, not in a movement of concepts but rather in visual moments. The contrast within the image that intensifies up to antagonism proves to be a source for iconic forces, a place of power. Just how untrivial these reflections are is also shown in how interventions in the composition of the contrast completely change the mode of pictorial representation and its meaning. The four cases that follow are not merely an enumeration because they demarcate the dispositive within which the broad variety of pictorial phenomena have taken shape.

1) If the iconic conflict—even in the form of the slightest discord between the continuum and a single form—disappears, then the dividing of attention collapses. What we then see is no longer a painted image but rather paint on a surface with no materially based immaterial meaning. Think of the veins of polished marble or smoothed wood in which recognizable distinctions such as landscapes

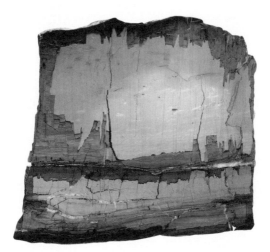

Fig. 12 *Ruin marble*
Collection of Cl. Boullé, Paris
Photograph by Flammarion

can appear without having originated from an artificial marking (fig. 12). Only the decision to look at such things as a representation is artificial and iconic.[21] In a different way, contingent klecksographic structures are selected for Rorschach diagrams-based on their suitability as projection surfaces for viewers to read their individual fantasies into.

2) A separate category is formed by representations in which nuance is exploited such that it covers a surface, for example, in the form of a finely meshed pattern, a patchwork rug, or the lattices of minimal art. While there isn't any doubt in these cases that a difference is artificially arranged, the contrasts remain below the threshold of perceptibility. As a consequence, the attention of the gaze is also no longer able to become divided, and the constitutive differences oscillate into one another. They are energy fields that have also been elaborated as iconic manifestations, such as by Bridget Riley (fig. 13).

3) Of another kind are camouflages, originally evolved in living beings as a disguise or commonly used as a military technology.[22] Camouflage has to do with a differentiable being (for example, a chameleon)

21 See Roger Caillois, "Natura Pictrix," in *The Mask of Medusa*, trans. George Ordish (New York: Clarkson N. Potter, 1964), 43–54; Jurgis Baltrušaitis, *Aberrations: An Essay on the Legend of Forms*, trans. Richard Miller (Cambridge: MIT Press, 1989), esp. 59–105 with regard to "pictorial stones."

22 See Caillois, *The Mask of Medusa*.

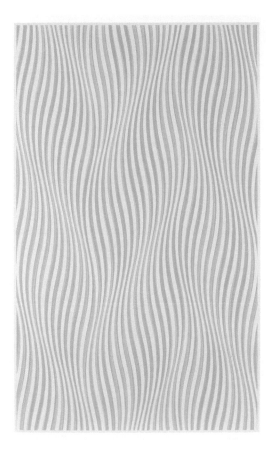

Fig. 13　**Bridget Riley**, Elapse, 1982
　　　　Screen print in color on BFK Rives paper, 102 × 63.9 cm

making itself invisible through visual assimilation to its surroundings. The particular composition of a visual continuum (for example, the foliage of a bush or the colorful structure of a terrain) functions like a hiding place when the thing in question succeeds in equipping itself with the same visual structure (fig. 14). Warhol and others have transferred this technique of dissimulation into some of their images, probably with the primary intent of disclosing, in this way, the conditions of how images show something.

4) A last example: in the case of simulation, what is represented effaces the possibility of experiencing its representedness, at least for a certain time. What is represented appears as if it were reality. To that extent, it is no longer an image but rather the thing. It has to do with transforming pictorial-appearing into simulation and activating the image's potential of deception, the trompe-l'œil—a concept that has also served as the name for this type of image, for which a painting by Samuel van Hoogstraten (fig. 15) can serve as a paradigmatic example. The conflict between pictorial expression and its effacement is transformed here in a momentary iconoclasm. Traditional trompe-l'œil paintings usually give away their deceptive intention quickly. But there is no disappointment associated with this; on the contrary, one feels admiration in the face of the stupendous virtuosity of the artist, who not only reflected on and saw through the logic

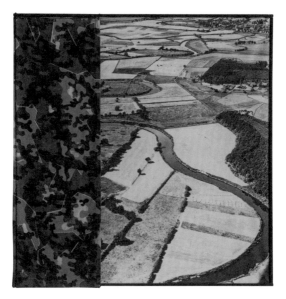

Fig 14 **Timm Ulrichs**, The Camouflaged Image or First and Second
Nature (Landscape as Artistic Landscape), 1968
Multiple, photographic emulsion on canvas and
camouflage material, 102.5 × 102 cm
Forschungsstelle Timm Ulrichs

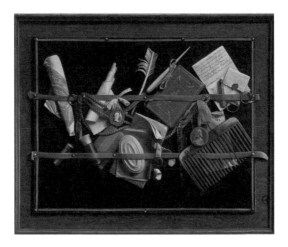

Fig. 15 **Samuel van Hoogstraten**, Trompe-l'œil Still Life, 1666/78
Oil on canvas, 63 × 79 cm
Kunsthalle Karlsruhe

of the representation but also understood how to effectively express it—even against that logic.

This series of examples demonstrates that the particular expression of iconic difference determines the specific character of pictorial meaning; it decides what is answered through attention as a responsive meaning. We come across cases in which the critical constitution or elimination of difference also results in complete withdrawal from the image. That means iconoclasm can also be produced using pictorial self-organization; it then debilitates or negates the selected way in which its meaning is made.

All of these reflections make clear that a gap or fissure opens up between the representation (the place of the iconic process as a continual totality) and the represented (the particular appearing object). This is a cleavage that cannot be closed. The gap is also the precondition for a particular meaning to be able to become manifest, for something to show itself as something at a material place. It indicates how the singular iconic conflict is settled. The dispute present in the image also serves as a lasting initiator for everything emerging from the image as an effect (emotion, liveliness, rhythm, peace, etc.). But the dis-identity associated with the gap also forces the splitting of the gaze and induces us to train our attention so that it is capable of grasping the moments of difference and of resolving their inner antagonism.

Return to the ground

In the cleavage of iconic difference, the continuum of the ground proves to be a definitive and guiding dimension, entirely opposed to the usual perception of the image that focuses on the represented. Let us now analyze this inversion of the relation between the ground and the represented, beginning with two examples from the field of early modern art.

The first concerns Francisco de Zurbarán's *Still Life with Vessels* (fig. 16). At first sight, our attention seems to be entirely directed to the things, so much so that they seem close enough to grasp, that—as the criticism has occasionally noted—an ontological presence is attached to them. But the painter does not intend in this case to form an illusion in the sense of a trompe-l'œil. Instead, the things owe their strong appearance to the unusual profundity of the darkness, which first endows the light on the things with its precious presence. It is the black ground that does not mark any back end of the image but rather spreads out like a medium. The shadows that emanate from it wrap around the bodies of the receptacles and underlie their positions. The darkness also flits along the table edge to the front image plane. Darkness everywhere. John Berger therefore said that "the true subject of the painting is the darkness behind, the darkness in

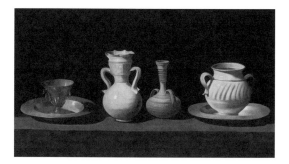

Fig. 16 ***Francisco de Zurbarán***, Still Life with Vessels, ca. 1650
Oil on canvas, 46 × 84 cm
Museo del Prado, Madrid

which everything is invisible," and it was probably its omnipresence that induced him to refer to this ground as "an *infinity*."[23] In any case, it proves to be an effective agent in the image, an agent that determines the phenomenal mode of what is represented.

Whoever is even just rudimentarily familiar with the art of drawing—and with that we come to the second example—knows that an autonomous ground plays a dominant role in it, especially when the sheets are not developed like an image but rather serve an initial, sketching imagination. Integrated in very different ways with the facture of drawing, the power of the ground provides the visible with a characteristic physiognomy and effect. In contour drawings, which arose in the tradition of disegno (by Raffael and Michelangelo up to Ingres and on; fig. 17), one can observe how the empty spaces between lines are placed under a tension so as, for example, to imagine the tangibility of a body, to make it possible to experience the tautness of the skin or other sensual qualities with, mind you, nothing other than the "empty" interven-

23 John Berger, "How Is It There? An Open Letter to Marisa," *Australia Art Monthly*, September 2000, 17. On the role of the ground in general, see Henri Maldiney, "L'art et le pouvoir du fond," in *Regard, parole, espace* (Lausanne: L'age d'homme, 1973), 173–207; Jean-Luc Nancy, *The Ground of the Image*, trans. Jeff Fort (New York: Fordham University Press, 2005); Gottfried Boehm and Matteo Burioni, eds., *Der Grund: Das Feld des Sichtbaren* (Munich: Wilhelm Fink, 2012).

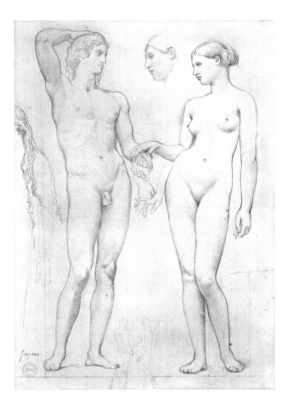

Fig. 17 **_Jean Auguste Dominique Ingres_**,
Studies of a Man and a Woman for "The Golden Age," ca. 1843
Graphite drawing on cream wove paper, 41.6 × 31.5 cm
Harvard Art Museums, Fogg Museum, Cambridge

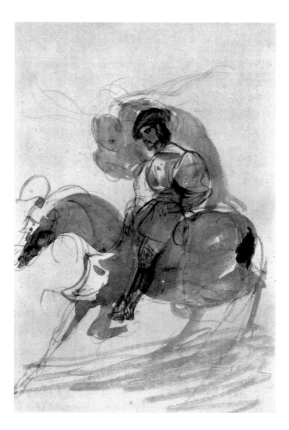

Fig. 18 **_Eugène Delacroix_**, The Constable of Bourbon Pursued by
His Conscience, ca. 1835
Brush wash in sepia over black chalk, sheet: 30.6 × 22.1 cm
Kunstmuseum, Basel

ing space making that energy and fullness manifest. "Painterly" drawings follow a totally different strategy: they achieve a sketch-like openness that emphasizes surfaces using hatching, curves, and stippling. It is not accidental that such drawings are made by colorists, by Titian, Rembrandt, Goya, and Delacroix, who also drew with a paintbrush (fig. 18).

The history of arranging the ground is rich and old, but it first reached its high point in the course of modernity. Formulated placatively, modernity brought about an emancipation of the ground that began with Chardin, Cézanne, Monet, and Seurat, then became very apparent in the idea of the abstract image in Malevich and Mondrian, and finally culminated in the concept of the monochrome image. In Yves Klein's monochrome blue (fig. 19), for example, or Barnett Newman's unbounded, "all-over" paintings, viewers see themselves confronted with an inescapable energy of a ground that dominates everything and is only stimulated by a few discrete opposing accents.

Breaking from the previous generation, Cy Twombly takes up the emptied and centerless image surfaces of abstract expressionists but lends them a multilayered subtleness. He tuned them to the color white. Twombly himself spoke of the "reality of whiteness" as "the landscape of

Fig. 19 **Yves Klein**, Blue Monochrome (IKB 242 A), 1958/59
Blue pigment and resin on paper, 21.5 × 18.1 cm
Private collection

my actions," a reality that "may exist in the duality of sensation (as the multiple anxiety of desire and fear)." It has to do with a large repertoire that encompasses linear actions and colorful blots, a gesture of writing (that reaches back before alphabetic scripts) but also numbers and schemata. He strives for "a synthesis of feeling, intellect etc."[24] Here I can only note in passing that drawing with an empty and at times space-consuming ground has attained an exceptional role since the end of the twentieth century.[25]

In the 1961 drawing *Untitled* (fig. 20), to which Twombly appended the suggestive name *Notes from a Tower*, the immediacy of the graphic traces opens up a highly ambiguous view from above into the distance. The structure appears in a material light that in other instances can also take on erotic content. This is the case in *Triumph of Galatea* from 1961 (fig. 21), whose title cites the myth of the sea-nymph Galatea. In an ascending slant, a drawn and painted turbulent structure evokes something

24 Cy Twombly, [Untitled], in "Documenti di una nuova figurazione: Toti Scialoja, Gastone Novelli, Pierre Alechinsky, Achille Perilli, Cy Twombly," *L'Esperienza moderna* 2 (August–September 1957), 32.

25 On the role of drawing, see, among others, Angela Lammert et al., eds., *Räume der Zeichnung* (Berlin: Akademie der Künste; Nuremberg: Verlag für Moderne Kunst, 2007); Carolin Meister, "Ohne Illusionen: Von anderen Räumen der Zeichnung," in Lammert et al., *Räume der Zeichnung*, 170–79; Monika Leisch-Kiesl, *ZeichenSetzung | BildWahrnehmung*: Toba Khedoori; Gezeichnete Malerei (Vienna: Verlag für Moderne Kunst, 2016).

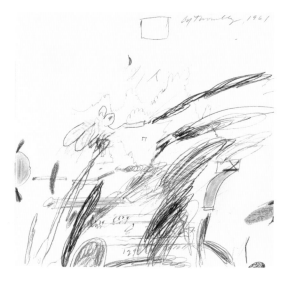

Fig. 20 **Cy Twombly**, Untitled (Notes from a Tower), 1961
Pencil drawing, wax chalks, and color pen, 33.2 × 35.5 cm
Private collection, Lugano

of the triumphal disposition of this both radiant and unapproachable Nereid, who plows through the sea on her dolphin-drawn chariot and hides from the dull desire of the Cyclops Polyphemus. Colorful flecks (a garish red or opaque ochre) give Twombly's painting an energetic emphasis. The subversiveness of the white ground is intensified in Twombly's canvases by white or cream-colored underpainting. Layered many times and ambiguous, these base coats are capable of letting something come to light as well as of hiding and effacing something. To this is added a notable intersection of flowing and halting qualities (fig. 21). Elsewhere I have shown how this structure initiates a process of remembering and forgetting. Twombly's work on memory equally possesses both individual and subjective traits as well as cultural and collective ones. What sets this process in motion is always the artist's "left" hand (in the sense that Roland Barthes referred to being left-handed), but its content is more than just biographically charged; Twombly takes up myths, poems, names, paintings, places, symbols, numbers, and more. We participate as beholders in this subjective and objective light, in a poetics of the ground with manifold resonances in painting and writing.

Twombly was probably one of the first to interpret the ground as an immediately effective space of experience, sensation, and memory. His reason

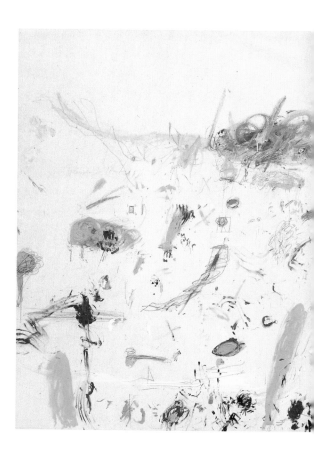

Fig. 21 **Cy Twombly**, Triumph of Galatea, 1961
House paint, industrial paint, oil, crayon, and
graphite on canvas, 294 × 483.5 cm
Menil Collection, Houston, gift from the artist

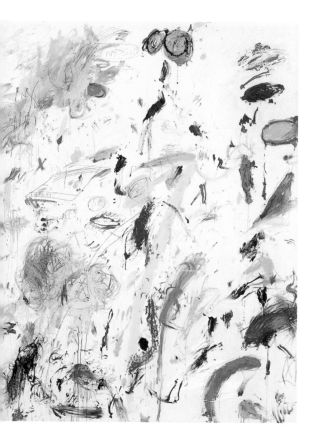

for doing so was not to convey conceptually or narratively comprehensible knowledge but rather to disclose open-ended worlds of meaning and sense. One generation earlier, the ground was disclosed through surrealism as a resonant zone for the pre- or subconscious. This particularly applies to Richard Oelze, who—unfortunately little known—was called the "only real surrealist" by no one less than Paul Éluard.[26] Oelze spent most of his life in self-imposed anonymity, engaged in developing a painting technique that brings the ground of the image into play in a way that is still unfamiliar to us. Let's consider his painting *Until the Day Comes* (fig. 22), which allows us to enter into a mysterious, twilit world. In it proliferate cell-like forms, often supplied with cyclopean eyes, in various sizes. We do not come across a biology but rather a phantasmagorical reality that stares at us with hundreds of gazes. In this painting, a nature-like morphology combines with architectonic remnants, whose ruinous state does not, however, suggest a dwelling. The ground is an affective potential of the uncanny, which, both aimless and demonic, does not follow any common teleology. Oelze's paintings live on metamorphic forces, which rise up and become embodied out of a basal formlessness. The difference opened in the image

26 Hans Kinkel, "Interior Landscapes," in *Richard Oelze: 1900–1980* (Cologne: Michael Werner 2016), n.p.

27 Kinkel, "Interior Landscapes."

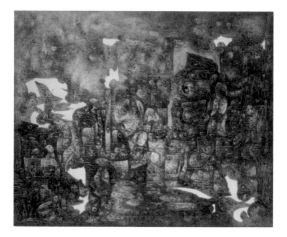

Fig. 22 **Richard Oelze**, Until the Day Comes, 1959/60
Oil on canvas, 98.5 × 125.5 cm
Galerie Brockstedt, Berlin

accompanies a threatening indeterminacy, which makes use of the flowing transitions. It is therefore also not surprising to encounter in Oelze references to Leonardo da Vinci's sfumato, which he relates to his white groundings.[27] Leonardo's painting practice of nuance not only already evoked smiles, cheerfulness, and grace; it also knew the profound, the threatening, and the enigmatic, that is, those preconscious experiences of an imaginary that dominates in Oelze.

Oelze did not, however, intend to captivate the viewer with horror scenarios. This also becomes clear in *Until the Day Comes*. One realizes that here unpainted zones have been cut into the continuum of the surface or, to state it better, have been left blank. These incisions interrupt the suggestiveness since they direct the gaze to the more deeply situated continuum of the pure canvas. Their formless materiality visualizes how painting begins and what it develops out of: the ground before the ground. Oelze subjects the subterranean, proliferating, uncanny metamorphoses that set his paintings in motion to an act of painterly enlightenment: the magician breaks his own spell, he shows his cards.

A binding rule for how to deal with the ground does not exist. Modern painting, which bid farewell to the canon of the academic tradition, was especially always about starting anew from the

ground up. The consciousness of this crisis was and still is widespread. The American painter Philip Guston gave it a particularly illuminating expression, probably because he was plagued by the assessment "that painting really doesn't have to exist at all … unless it questions itself constantly";[28] that is, unless it "proves its right to exist by being critical and self-judging" and so is equally on the path of reflection and painterly practice.[29]

Guston confronts the fundamental problem of "what a painting is."[30] It leads him to the peculiarity of the ground and the forces and effects that radiate from it. He first observes "an ambiguity of paint being image and image being paint, which is very mysterious."[31] These two moments open a fissure in which tensions and antagonisms become effective and merely painterly facticity transforms into visual meaning. The fissure that instates the image demands to be found or invented in each case, for which Gaston assumes a "most powerful instinct" as the driving force. This basic iconic process does not, however, become organized

28 Philip Guston, "Talk at 'Art/Not Art?' Conference (1978)," in *Collected Writings, Lectures, and Conversations*, ed. Clark Coolidge (Berkeley: University of California Press, 2011), 279.

29 Philip Guston, "Faith, Hope, and Impossibility (1965/66)," in *Guston, Collected Writings, Lectures, and Conversations*, 53.

30 Guston, "Art/Not Art," 278.

31 Philip Guston, "Interview with David Sylvester (1960)," in *Guston, Collected Writings, Lectures, and Conversations*, 26.

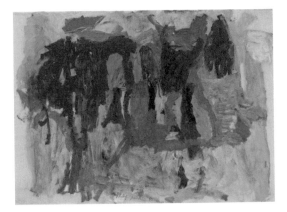

Fig. 23 **Philip Guston**, Untitled, 1957
Oil on paper on fiberboard, 63.5 × 88.9 cm
Hinterfeldt Collection

in just any way but rather through a specific marking that welds together the distinct form and the painterly continuum (fig. 23). If one follows Guston's statements, it is about painting "a single form in its continuity, which is after all what a face is."[32] In this painterly association originates what Guston calls the "imaginary plane"; in it is contained "almost all the fascination of painting for me." He continues: "I'm convinced that it's almost a key, and yet I can't talk about it; nor do I think it can be talked about. There's something very frustrating, necessary, and puzzling about this metaphysical plane that painting exists on. And I think that, when it's either eliminated or not maintained intensely, I get lost in it."[33]

The actual verification of these descriptions lies in Guston's paintings, which also arouse a particular interest because they developed both an abstract and a figurative register. In not a single case was he concerned with what in particular is represented—whatever character it might have—but rather with the articulation of the imaginary "picture plane" in its mysterious ambiguity.[34] In his painting *The Mirror* (fig. 24), one sees open colorful forms rising up from the ground, becoming organized in layers that both reveal and conceal. The suggestion

32 Guston, "Interview," 26.
33 Guston, "Interview," 21.
34 Guston, "Interview," 21.

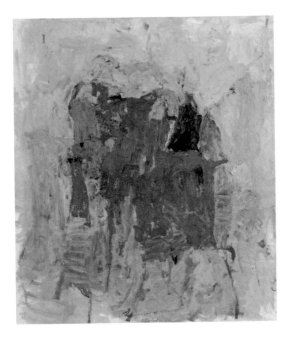

Fig. 24 **Philip Guston**, The Mirror, 1957
Oil on canvas, 172.7 × 157.5 cm
Collection of Adriana and Robert Mnuchin

of two heads or bodies surprise the gaze. Guston intensifies the imaginary of the picture plane by integrating the topos of the mirror. He substitutes, however, the familiar optical reflection with the imaginary ambiguity of the ground and its allusive abundance. Indeed, as you may recall, we refer to the capacity to conjure the reality of the unreal as the imagination; it is a magic that does not result from physical reflection but from the power of painterly material.

The painting *Paw* from 1968 (fig. 25) is characterized by how it also places the articulation of the ground before the eyes. We see a hand that reaches into the image from the right and holds or moves a paintbrush. And we see this on a second level: for the painting does not just show something painted but rather how painting occurs. The iconic difference becomes, very explicitly, the event that the painting is about. It thus shows on the thematic level what Guston saw as the fundamental impulse of painterly work, namely "to posit with paint something living, something that changes each day."[35]

The corporeally controlled hand, engaged in the act of painting, evokes what Guston called "instinct," a capacity that conceptually knows nothing and instead engages with a particular situation through

35 Guston, "Faith, Hope, and Impossibility," 54.

the eye, mind, and hand, through color, light, and canvas. Under these conditions, the artist finds a path that only becomes visible when one takes it. Or it does not. For success and failure is the defining feature of the artistic impulse.

Guston approaches this continual challenge with the words: "How do you know when you've finished?" Or, even more concisely: "When is a painting finished?" It is the question that Balzac already foisted on his failing painter Frenhofer in his novella *The Unknown Masterpiece*. His fictional painter is undone by the fact that he is unable to recognize the right moment to stop. By contrast, Guston's advice for this all-decisive situation reads as follows: "It's an immediate thing, it's a crucial moment. It's somehow a feeling of all your forces, all your feelings, somehow come together and it's got to be unloaded right then."[36] It is in the now when artistic embodiment comes to grips with its always singular conflict and mobilizes its forces.

Translated by Anthony Mahler

36 Guston, "Interview," 23.

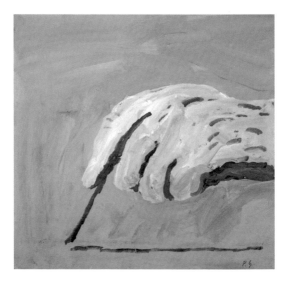

Fig. 25 **Philip Guston**, Paw, 1968
Acrylic on panel, 76.2 × 81.3 cm
Private collection

Selected Bibliography of
Gottfried Boehm's Publications

Bildnis und Individuum: Über den Ursprung der Porträtmalerei in der italienischen Renaissance. Munich: Prestel, 1985.

Paul Cézanne: Montagne Sainte-Victoire; Eine Kunstmonographie. Frankfurt am Main: Insel, 1988.

Was ist ein Bild? Munich: Wilhelm Fink, 1994.

Beschreibungskunst – Kunstbeschreibung: Ekphrasis von der Antike bis zur Gegenwart. Edited with Helmut Pfotenhauer. Munich: Wilhelm Fink, 1995.

Homo Pictor. Munich: K. G. Saur, 2001.

"In-Between Spaces: Painting, Relief, and Sculpture in the Work of Ellsworth Kelly." In *Ellsworth Kelly: In-Between Spaces; Works 1956–2002*, edited by Gottfried Boehm, 17–45. Riehen: Fondation Beyeler, 2002. Exhibition catalogue.

"Jenseits der Sprache? Anmerkungen zur Logik der Bilder." In *Iconic Turn: Die neue Macht der Bilder*, edited by Christa Maar and Hubert Burda, 28–43. Cologne: DuMont, 2004.

"A New Beginning: Abstraction and the Myth of the 'Zero Hour.'" In *Abstract Expressionism: The International Context*, edited by Joan Marter, 99–107. New Brunswick: Rutgers University Press, 2007.

Wie Bilder Sinn erzeugen: Die Macht des Zeigens. Berlin: Berlin University Press, 2007.

Movens Bild: Zwischen Evidenz und Affekt. Edited with Birgit Mersmann and Christian Spies. Munich: Wilhelm Fink, 2008.

Zeigen: Die Rhetorik des Sichtbaren. Edited with Sebastian Egenhofer and Christian Spies. Munich: Wilhelm Fink, 2010.

Der Grund: Das Feld des Sichtbaren. Edited with Matteo Burioni. Munich: Wilhelm Fink, 2012.

"Representation, Presentation, Presence: Tracing the Homo Pictor." In *Iconic Power: Materiality and Meaning in Social Life*, edited by Jeffrey C. Alexander, Dominik Bartmański, and Bernhard Giesen, 15–23. New York: Palgrave Macmillan, 2012.

"Genesis: Paul Klee's Temporalization of Form." *Research in Phenomenology* 43, no. 3 (January 2013): 311–30.

"'Eigensinn': Zeichen – Sprache – Bild: Bemerkungen zu Charles S. Pierce." *Sprache und Literatur* 44, no. 2 (November 2013): 90–113.

Die Sichtbarkeit der Zeit: Studien zum Bild in der Moderne. Munich: Wilhelm Fink, 2017.

Tuymans, Luc. *The Image Revisited: Luc Tuymans in Conversation with Gottfried Boehm, T. J. Clark, and Hans M. De Wolf.* Antwerp: Ludion, 2018.

Colophone

Edited by Carolin Meister

Design: Axel Heil, Christian Ertel, Manuel van der Veen,
Studio of Experimental Transfers, AdBK
Image editing: Christian Ertel
Translation: Anthony Mahler
Copy editing: Carolin Meister, Carolin Heel, Anna Schütten,
Manuel van der Veen
Portrait Gottfried Boehm: Pietro Pellini
Printing: Heinz W. Holler Druck und Verlag GmbH

ISBN: 978-3-96098-772-7

Published by Verlag der Buchhandlung Walther und Franz König

Distribution:
Buchhandlung Walther König
Ehrenstr. 4 | D-50672 Köln
Fon +49 (0) 221 / 20 59 6 53
verlag@buchhandlung-walther-koenig.de

With the kind support of

RIEMSCHNEIDER
Stiftung

**Staatliche
Akademie der
Bildenden
Künste
Karlsruhe**